Mandala Coloring Books
Copyright © 2017 Rosetta Hazel

All rights reserved. No part of this book may be reproduced or transmitted in any form or by any means, including but not limited to information storage and retrieval systems,electronic,mechanical,photocopy,recording,etc. without written permission from the copyright holder.

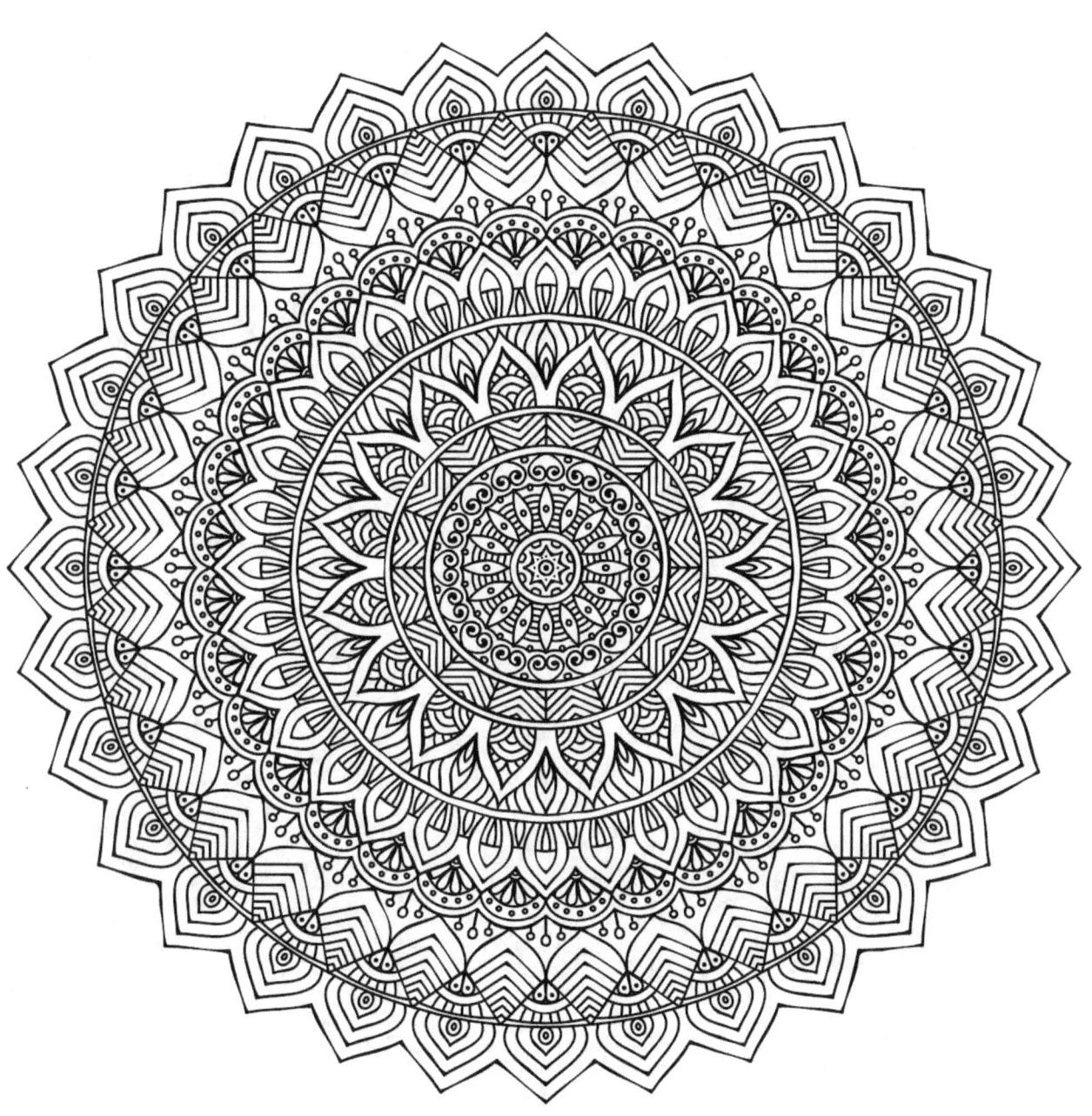

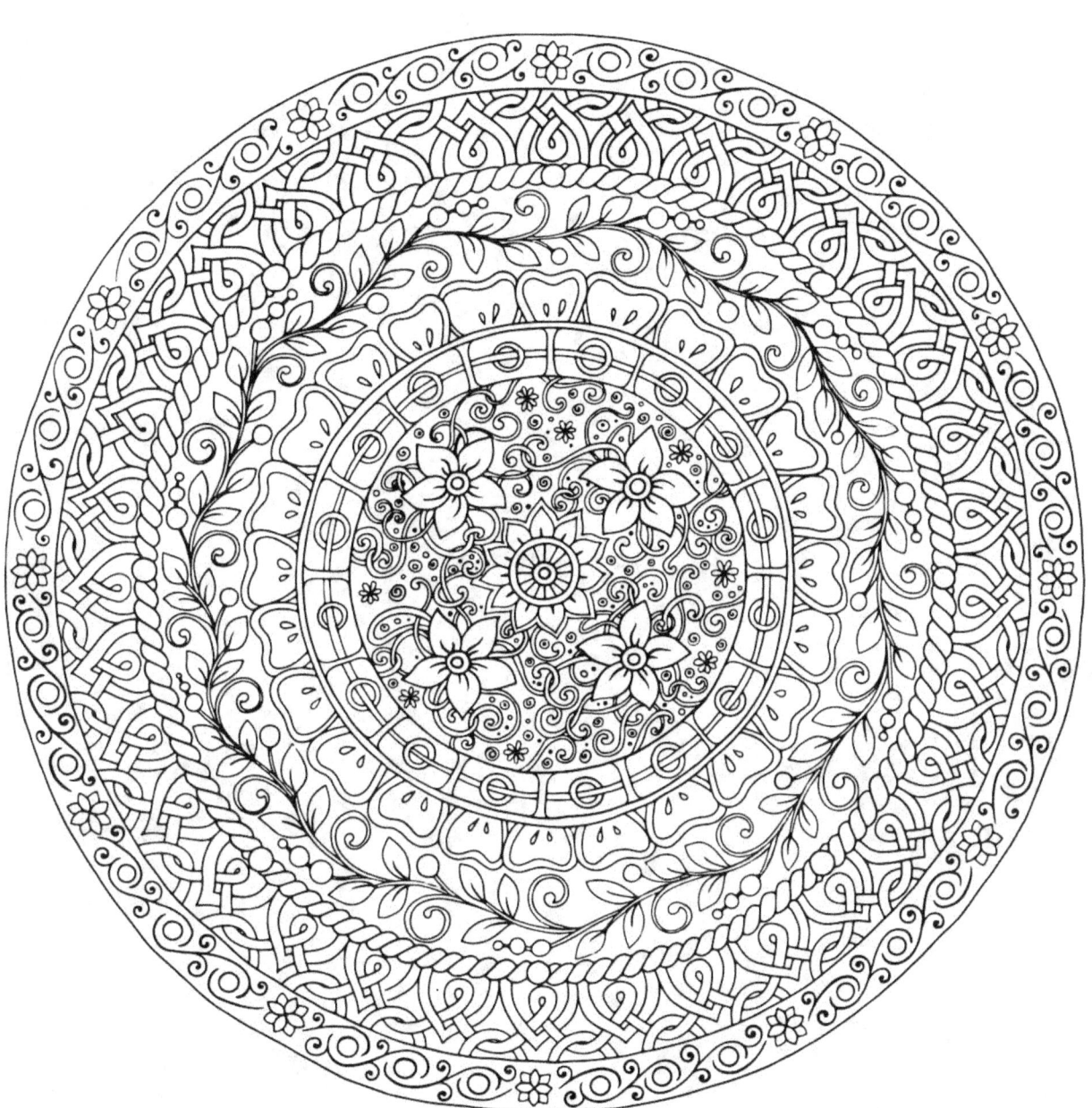

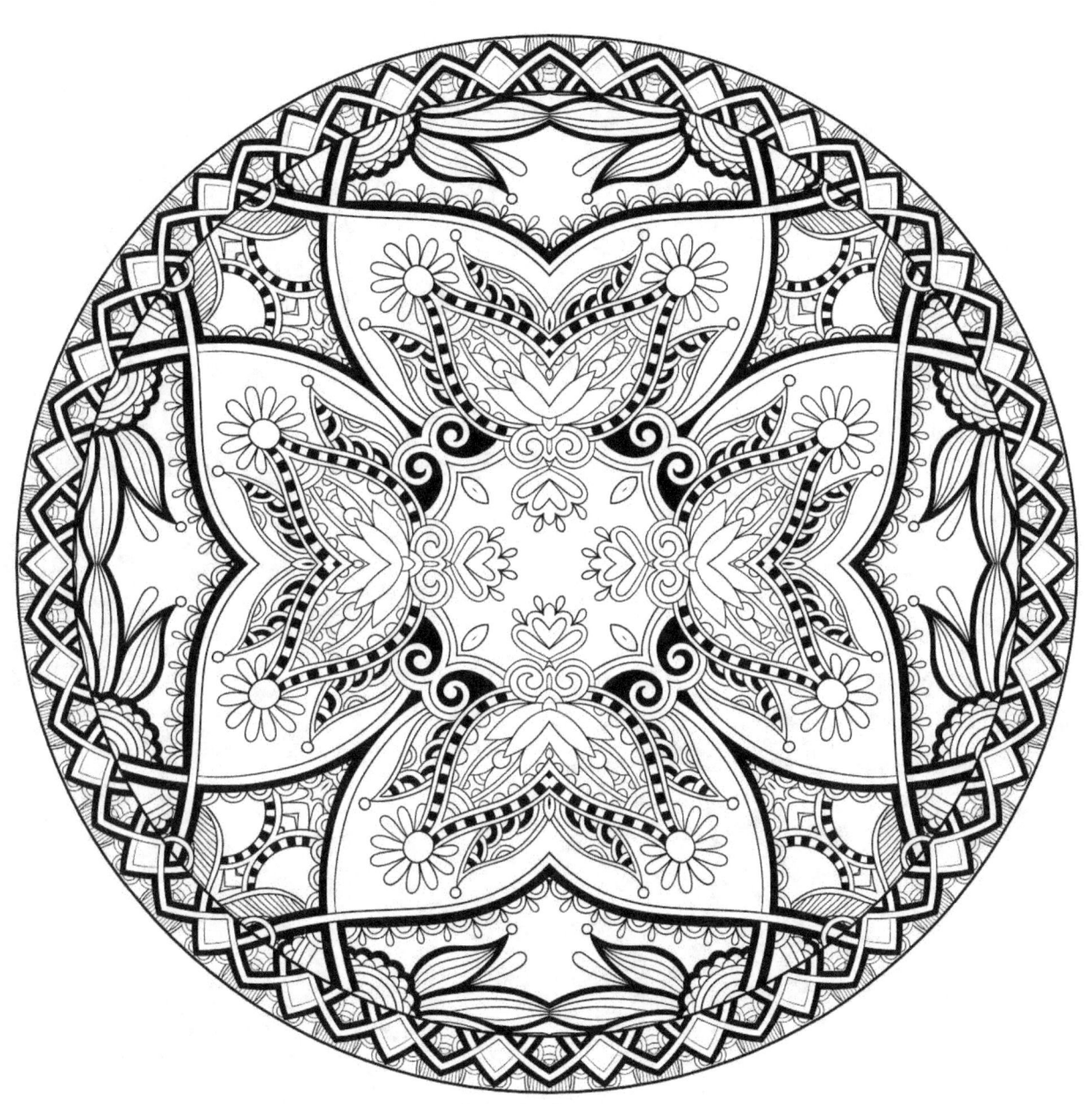

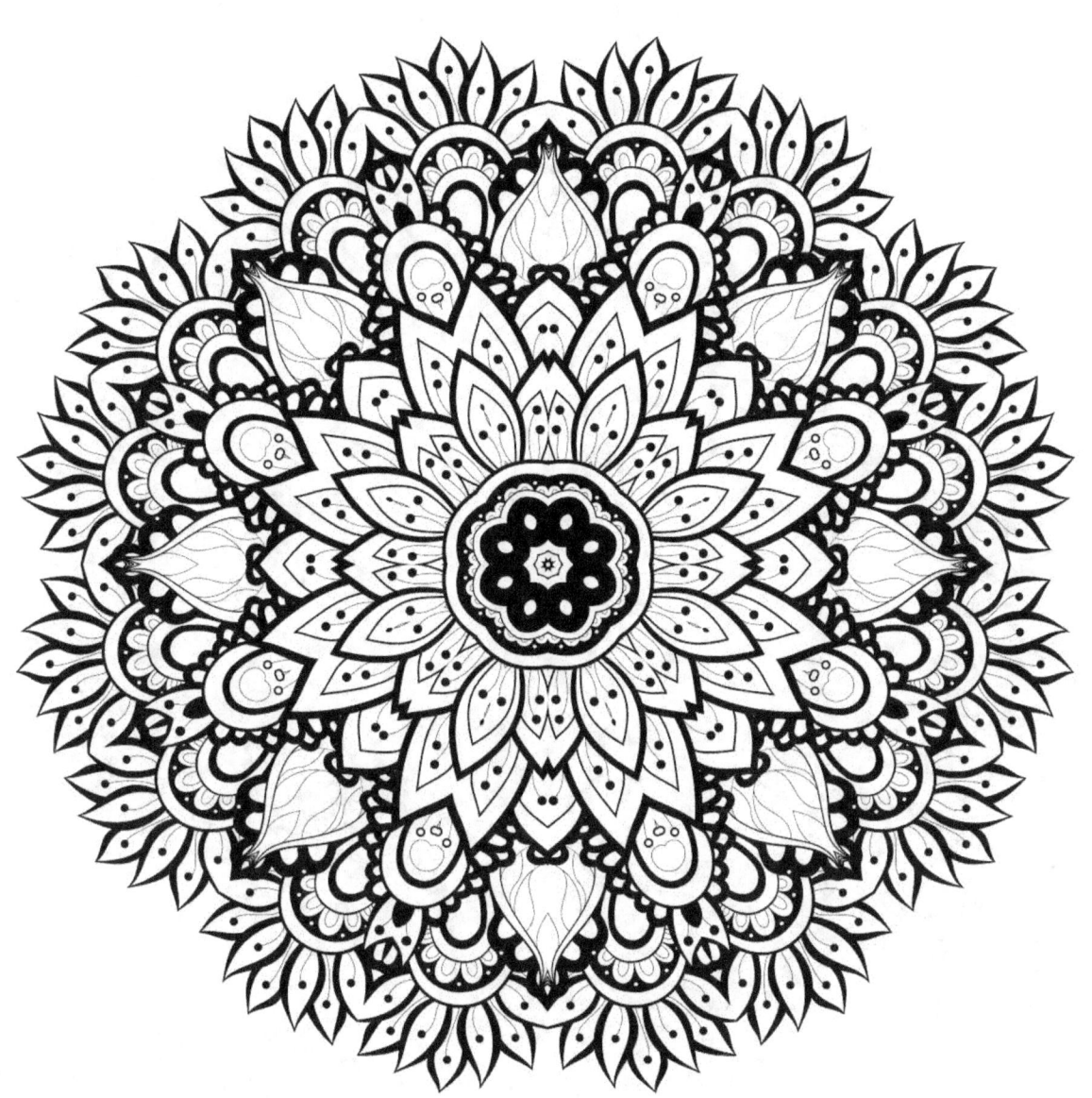

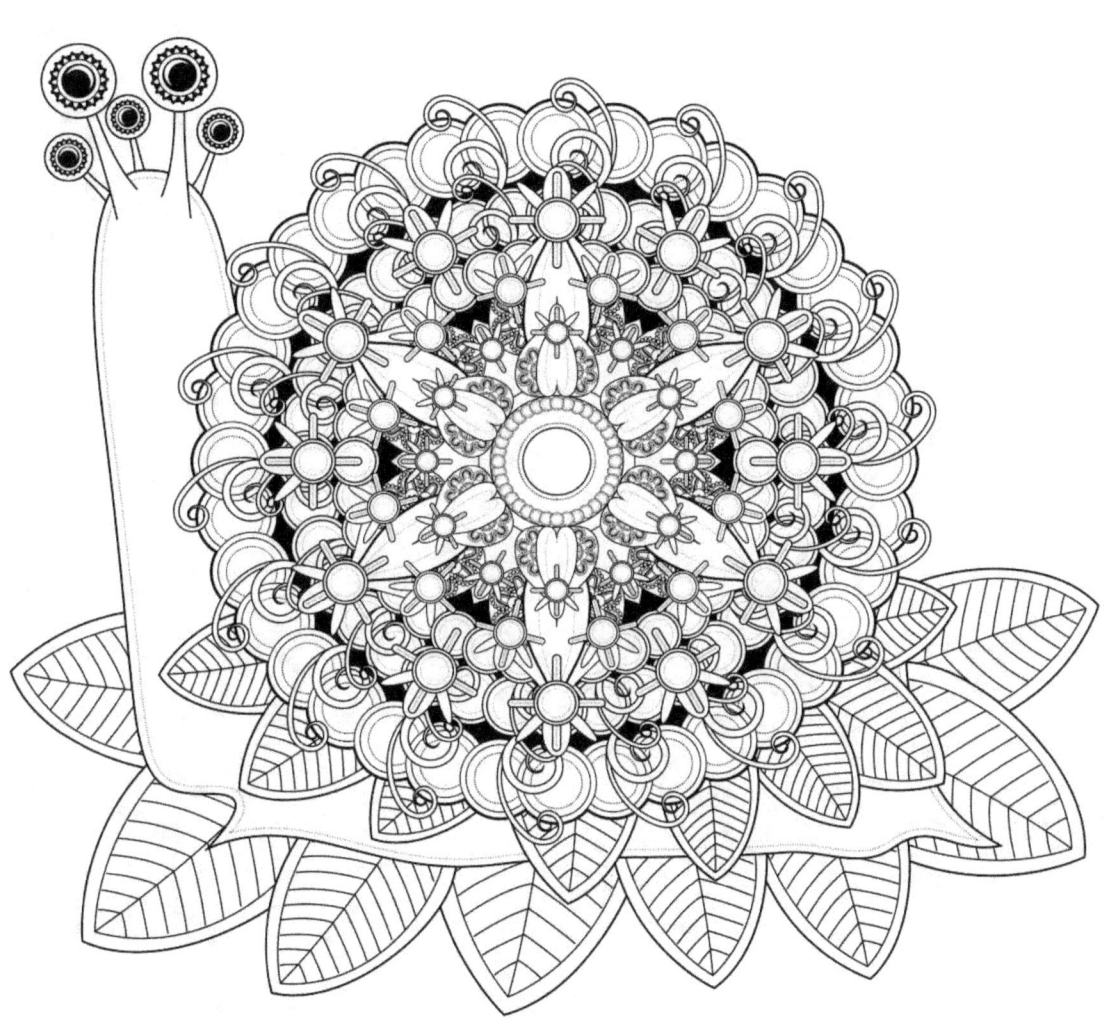

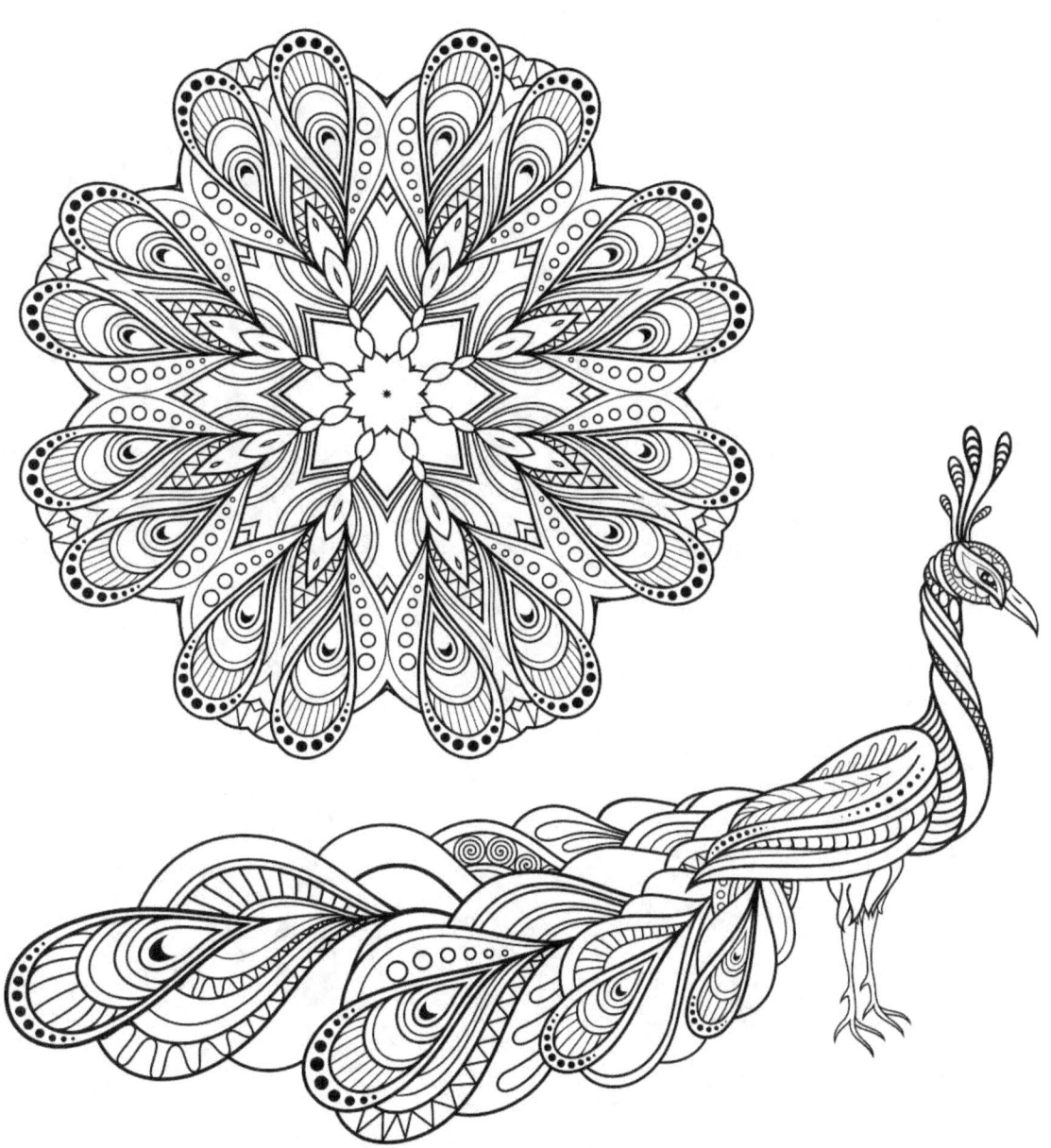

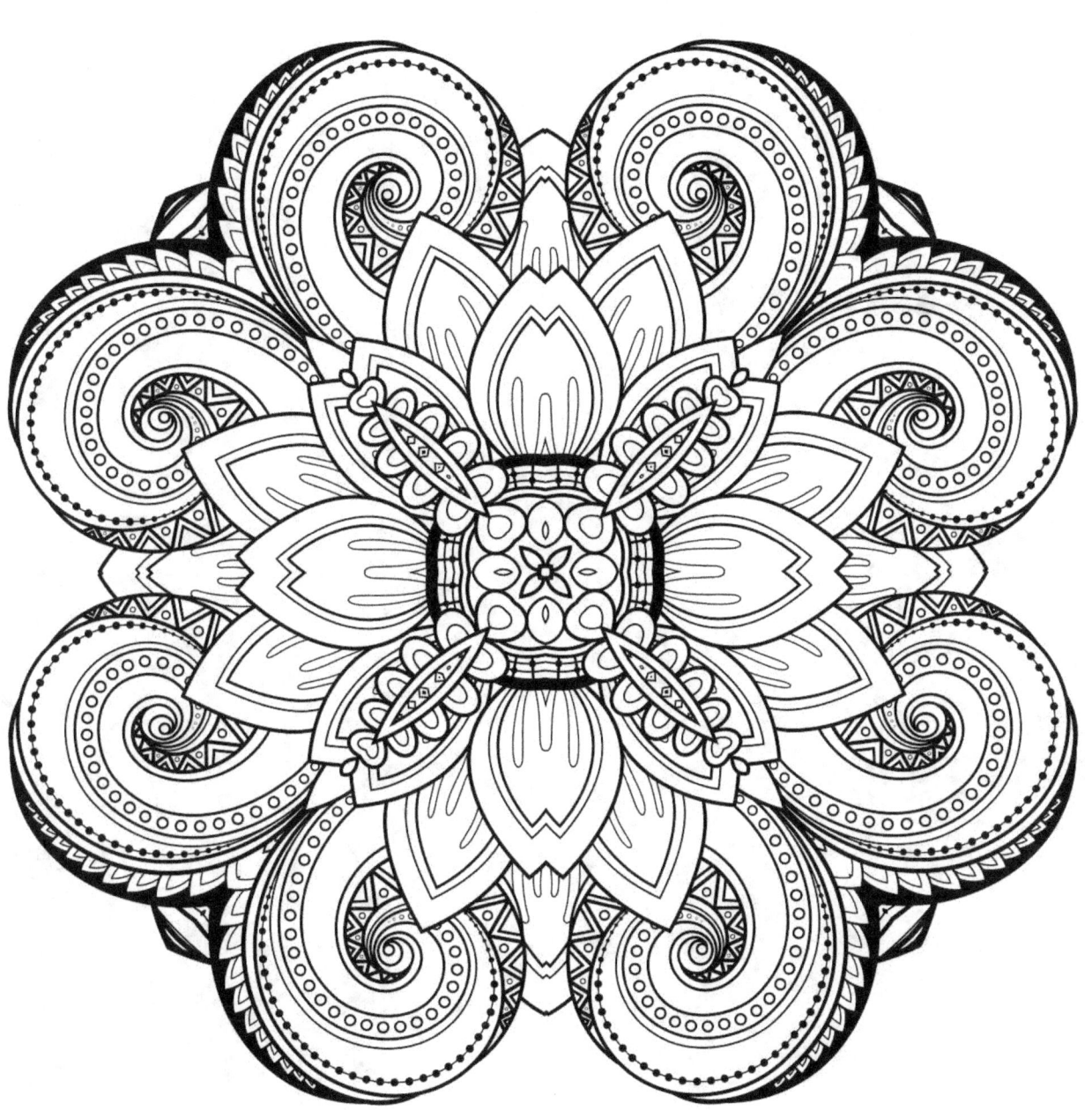

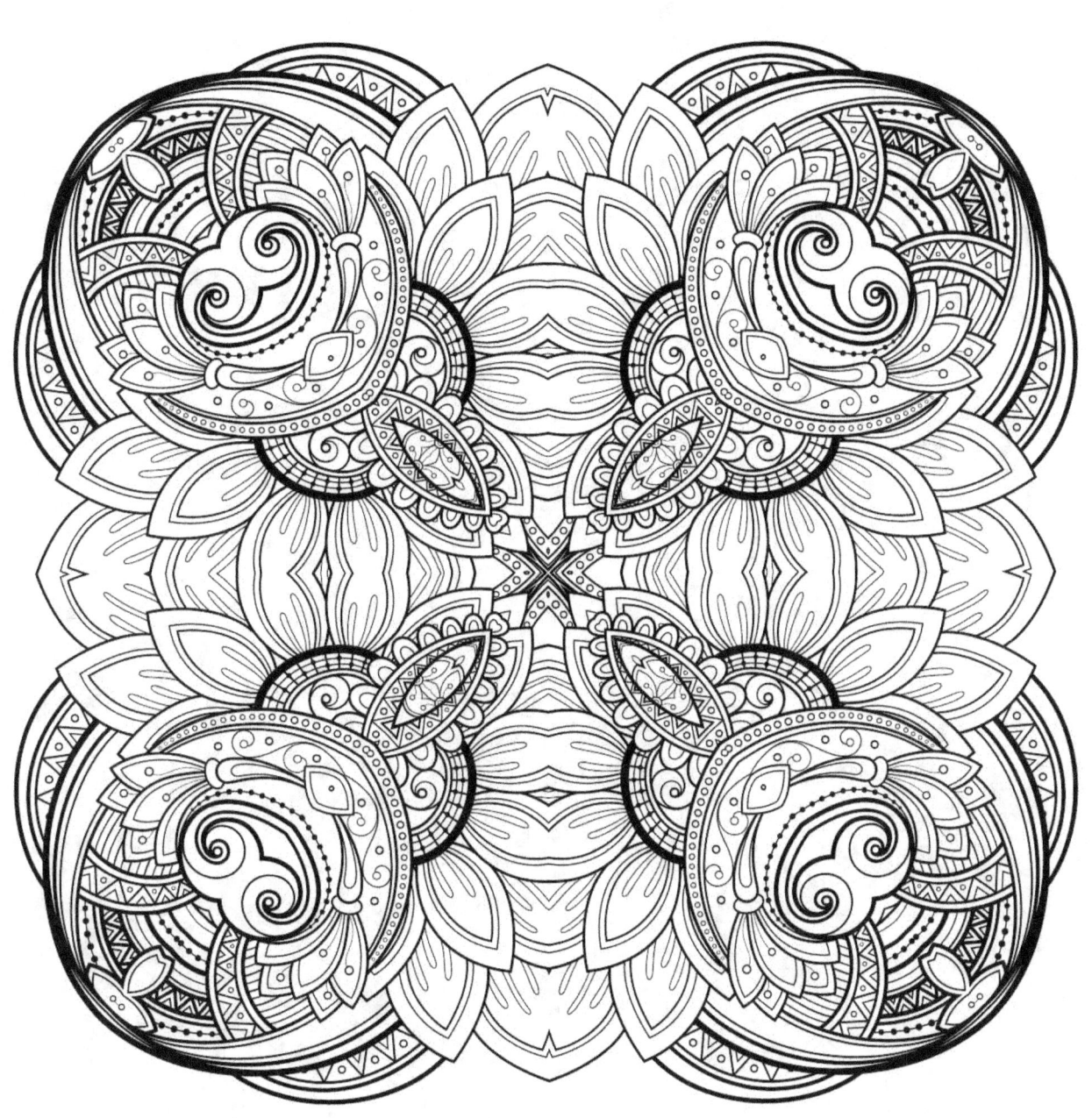

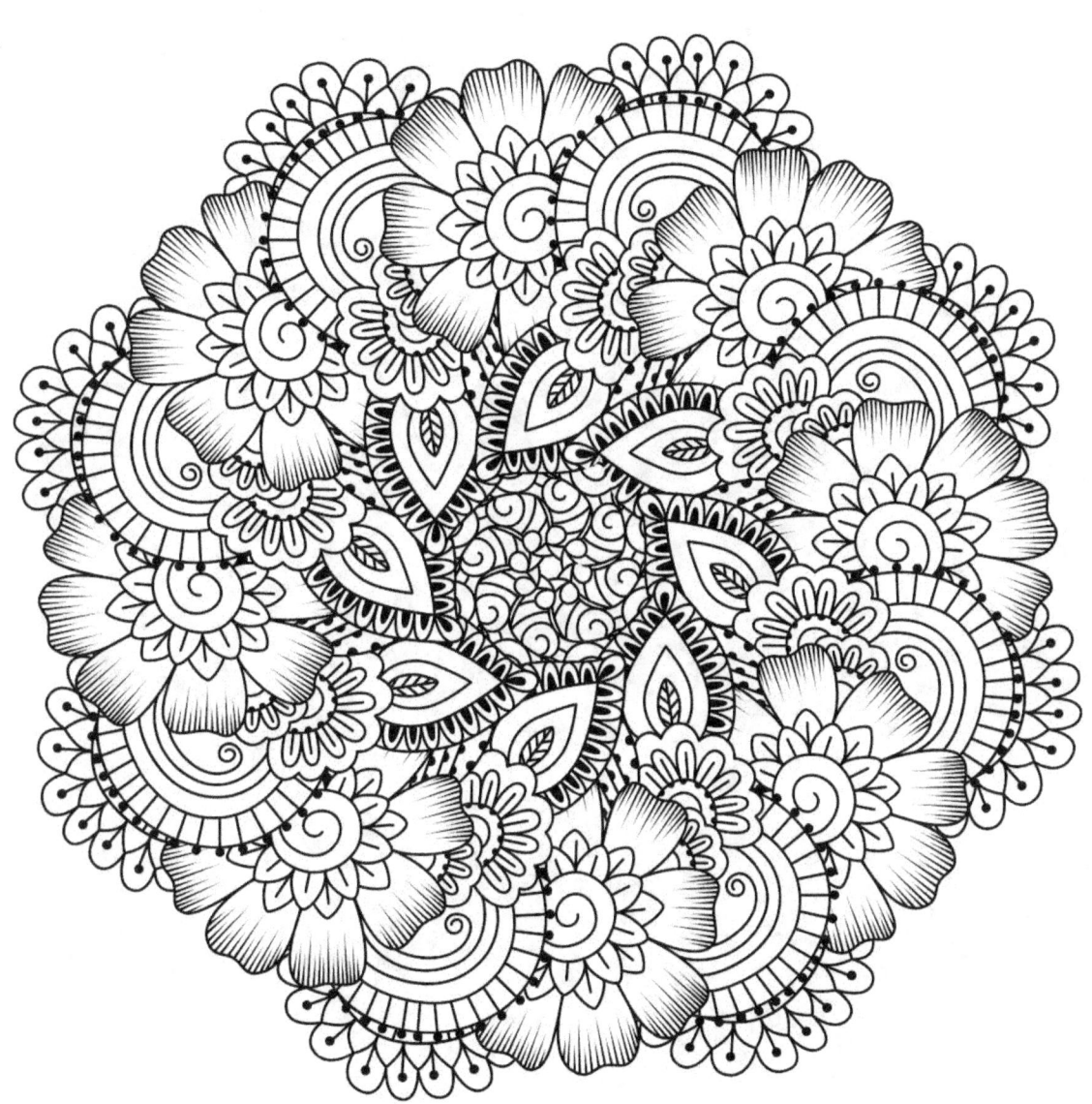

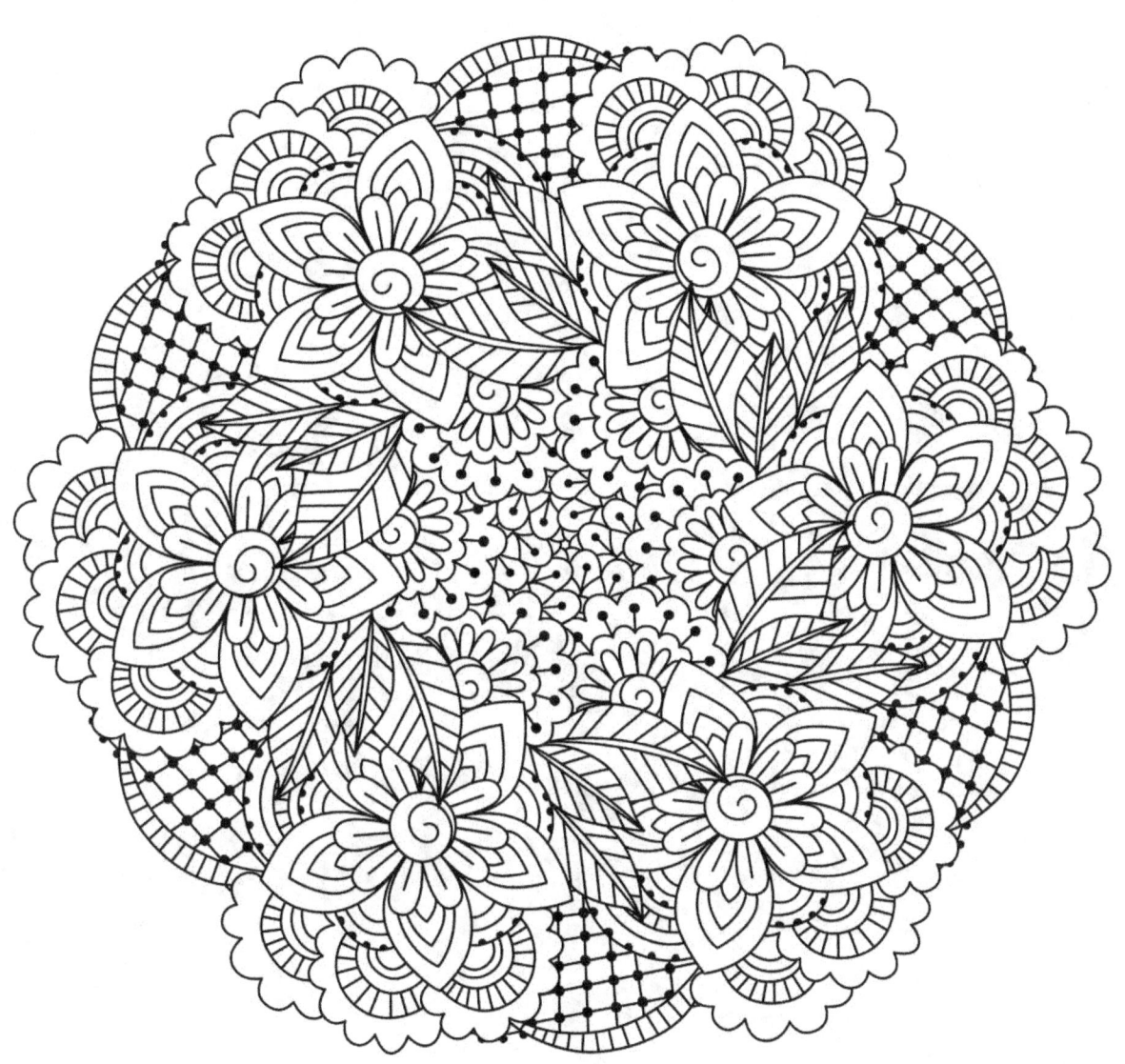

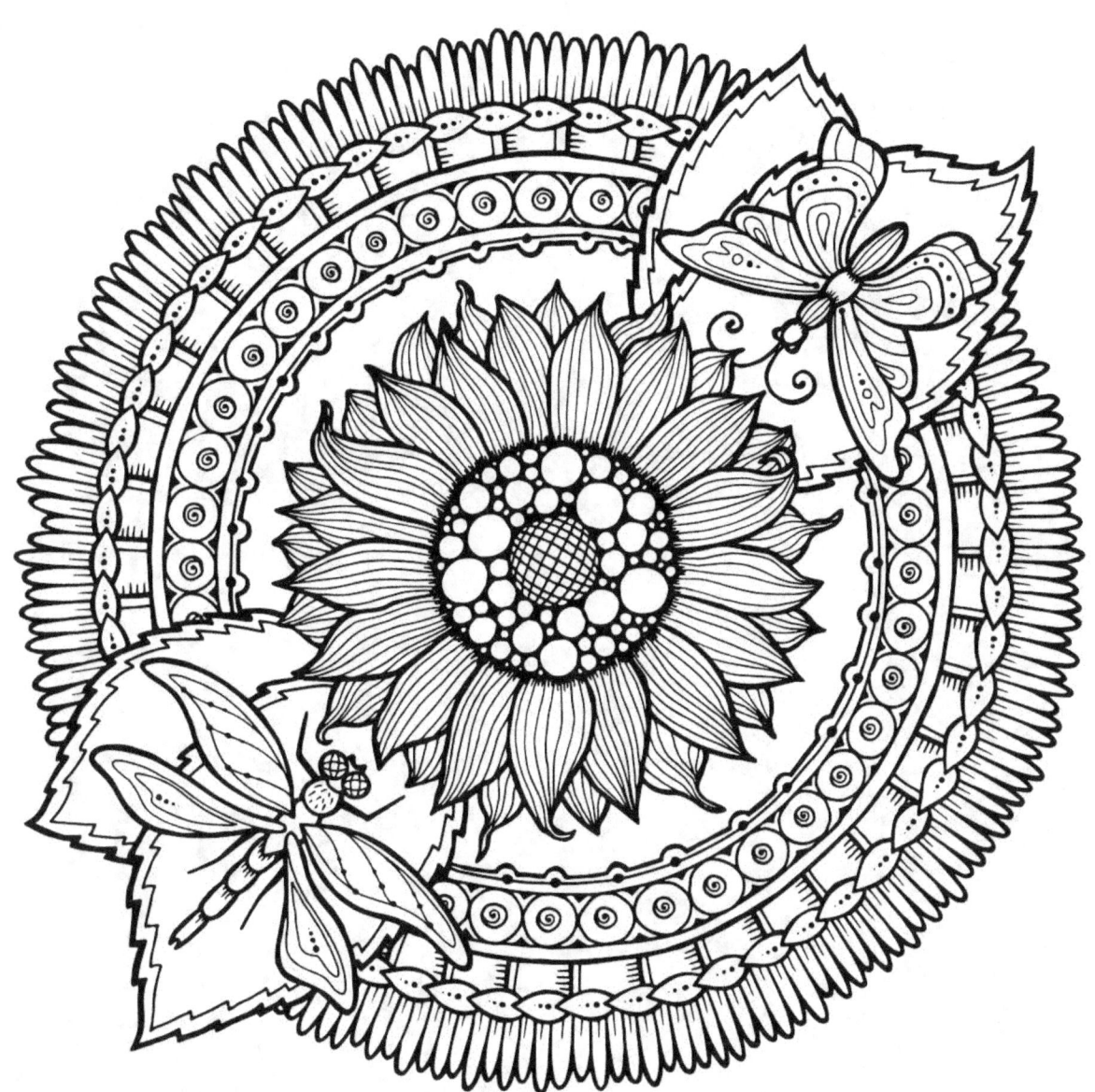

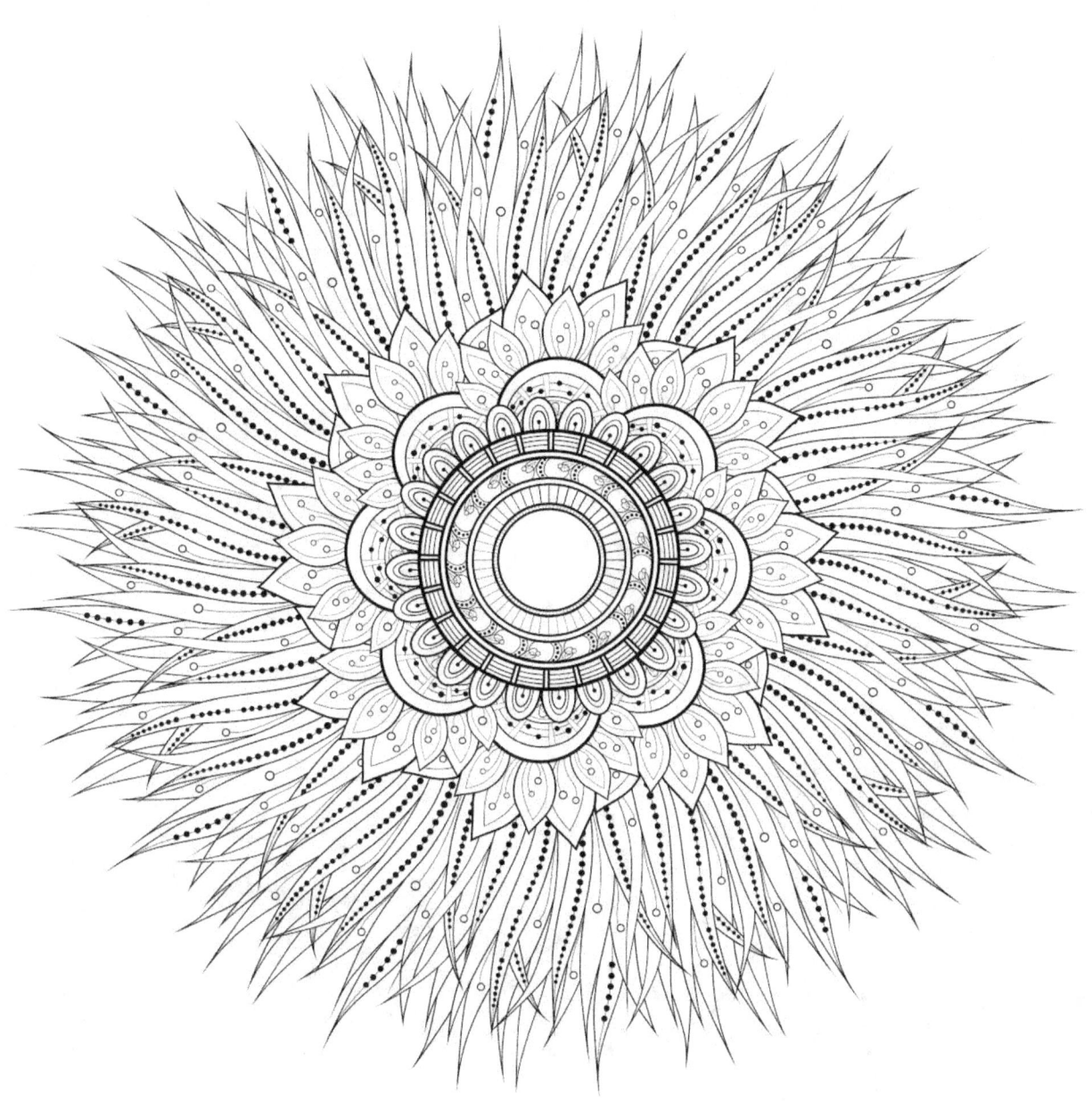

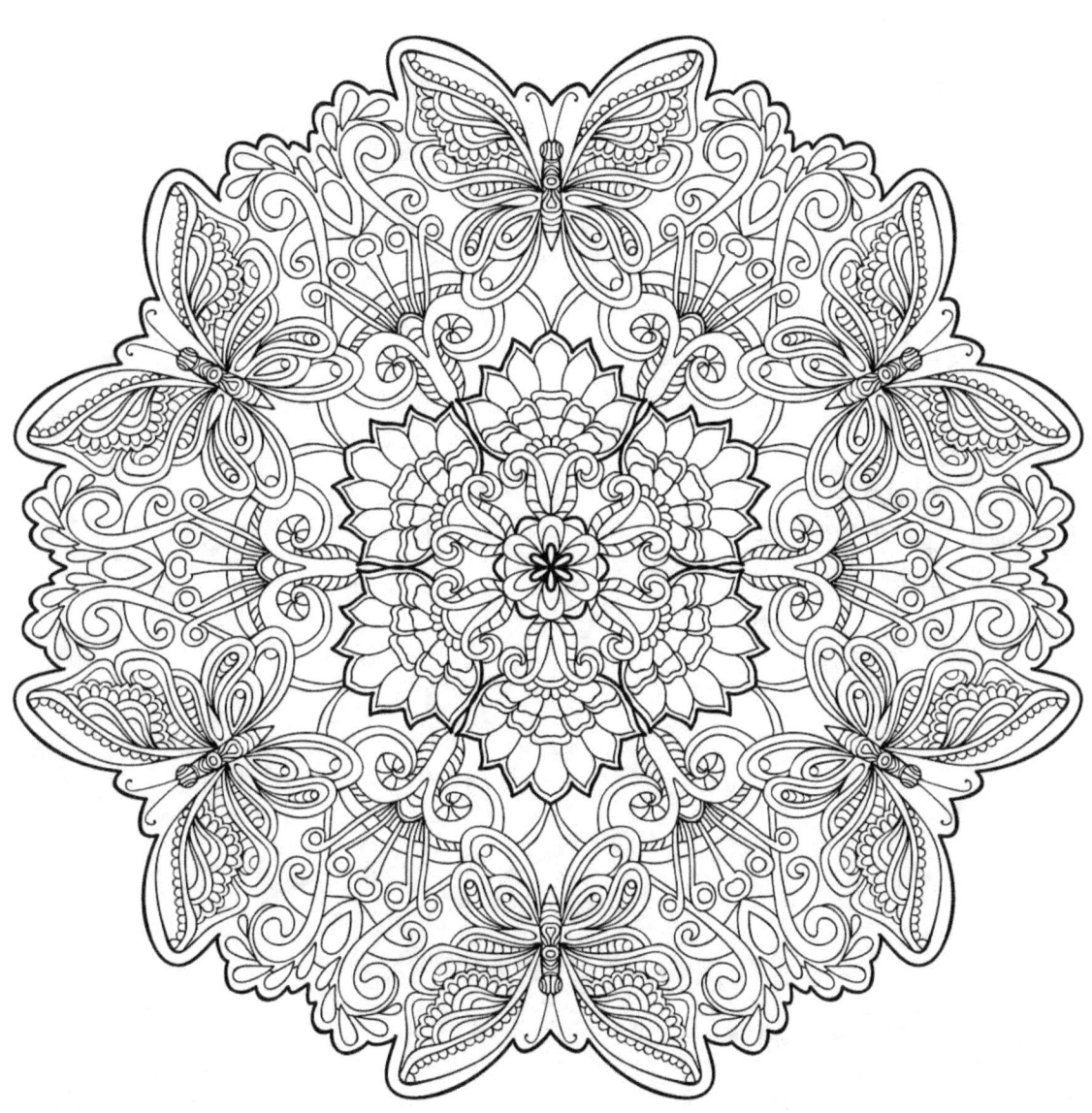

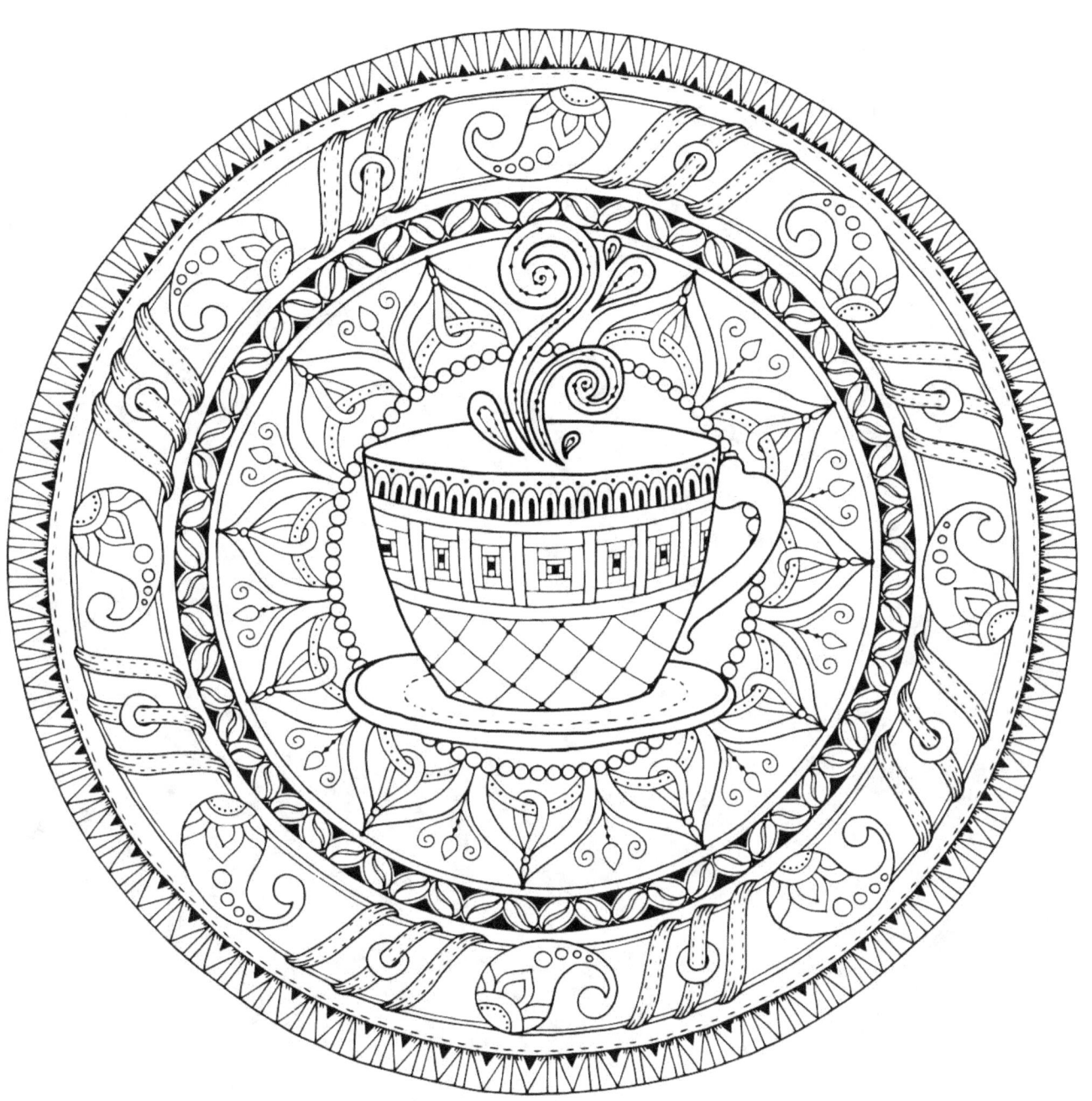

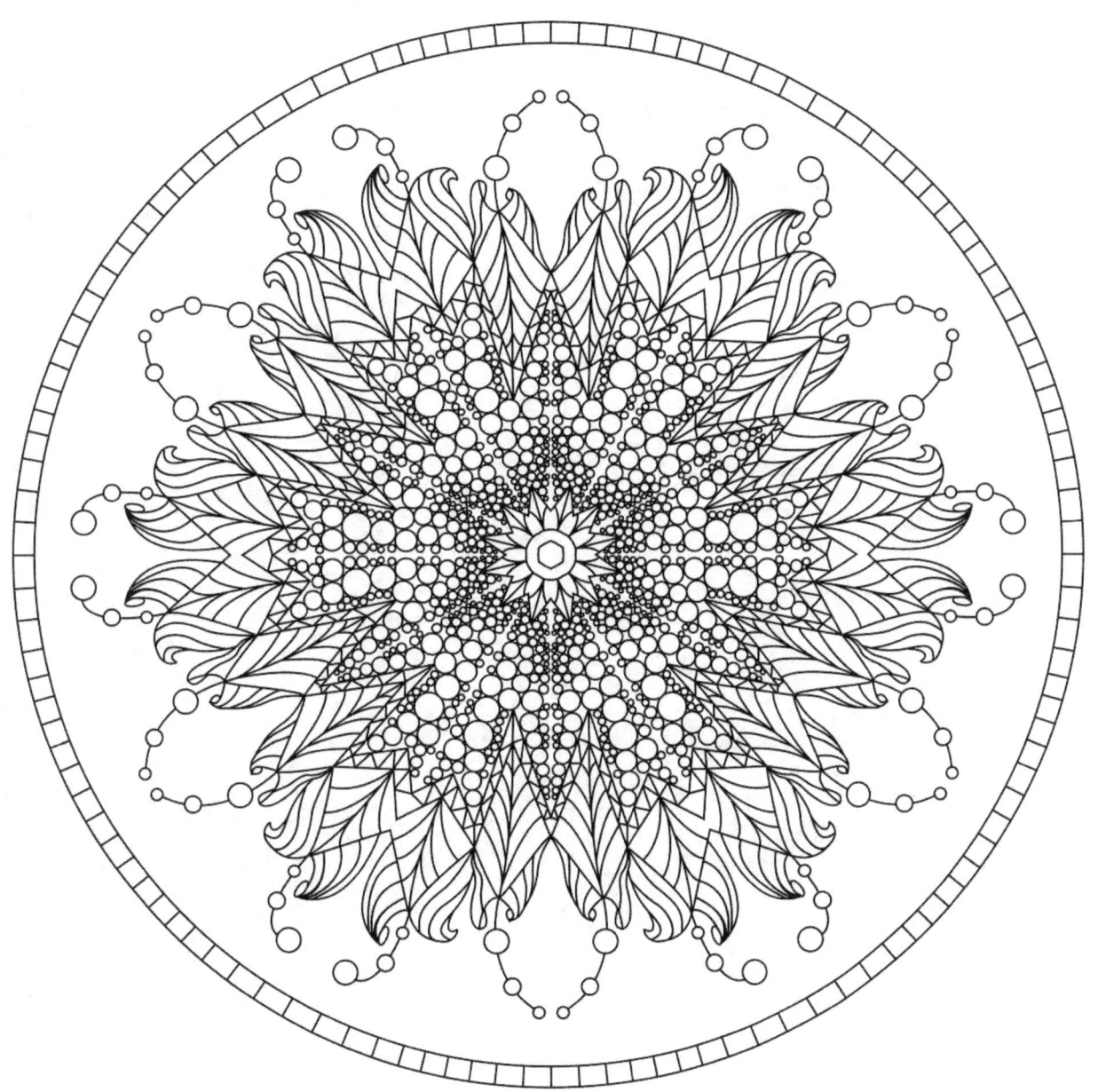

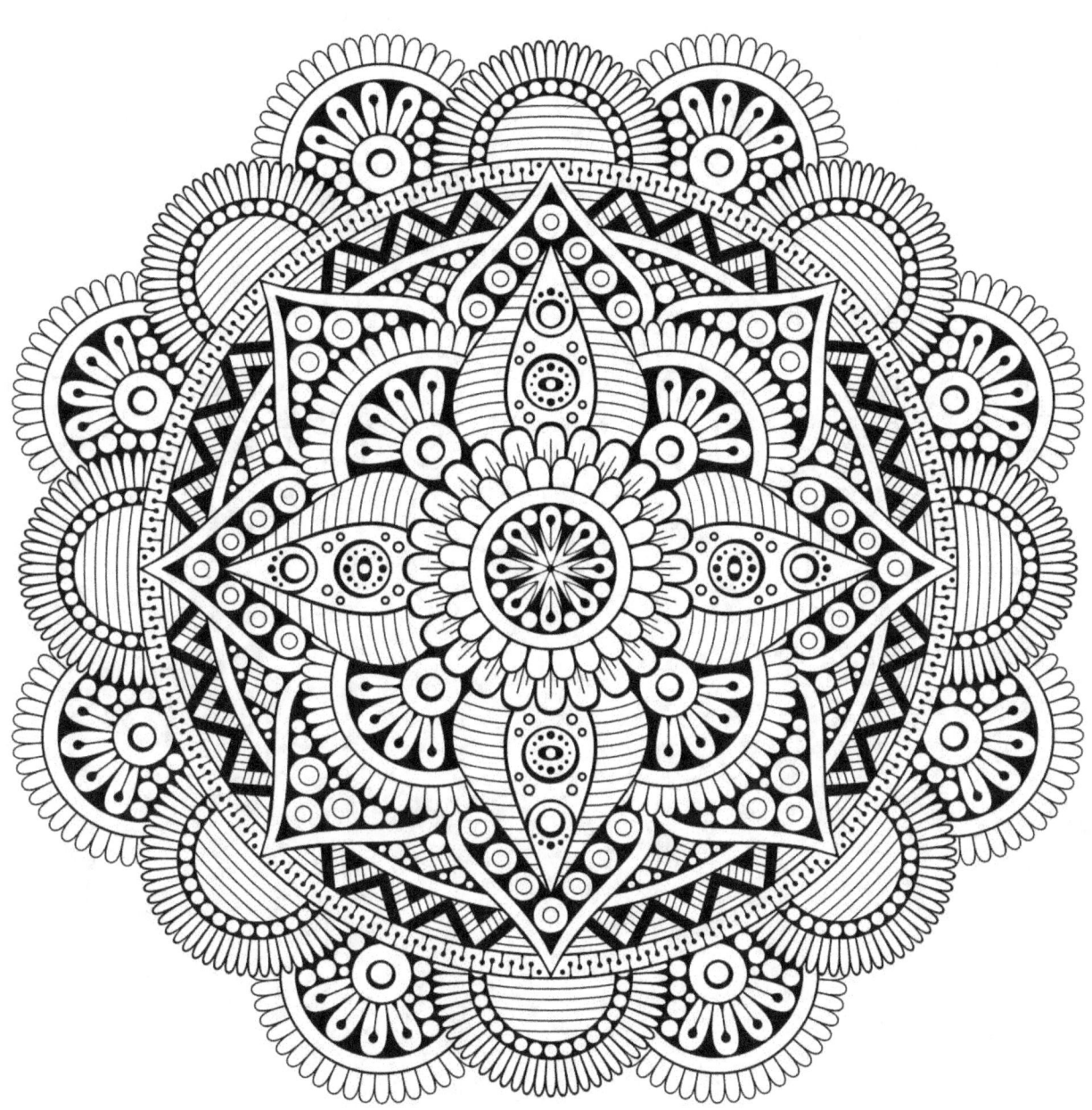

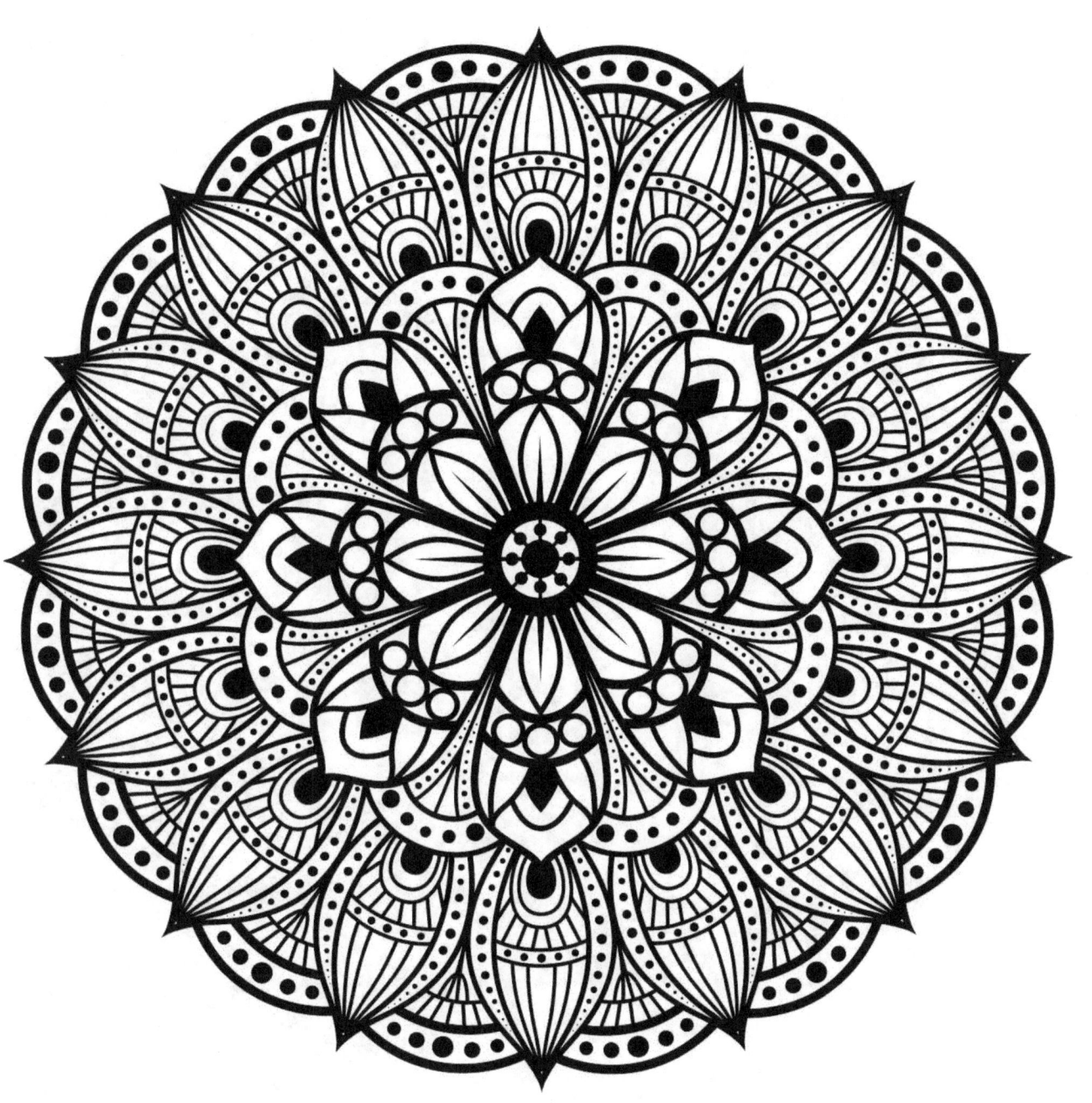

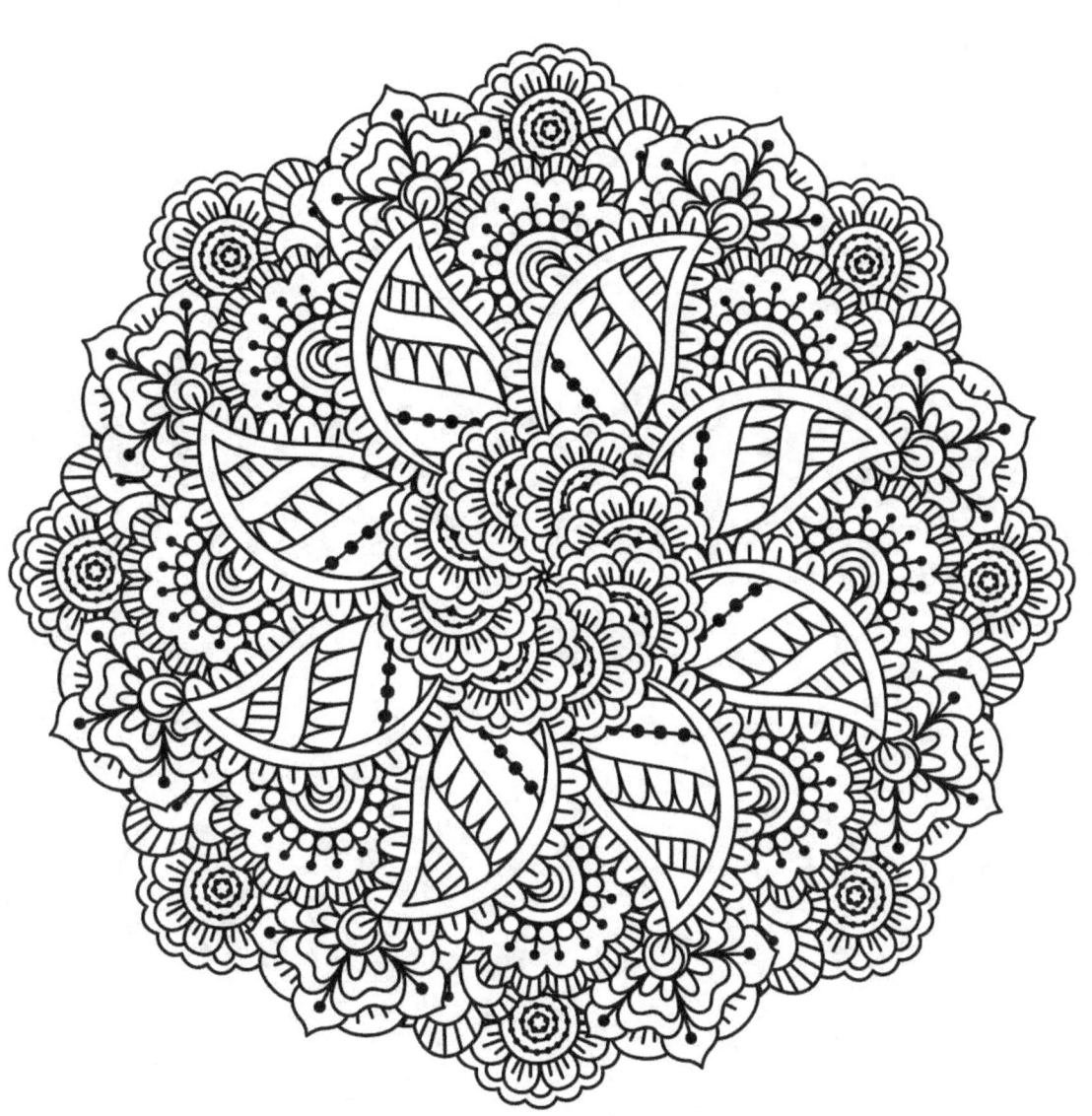

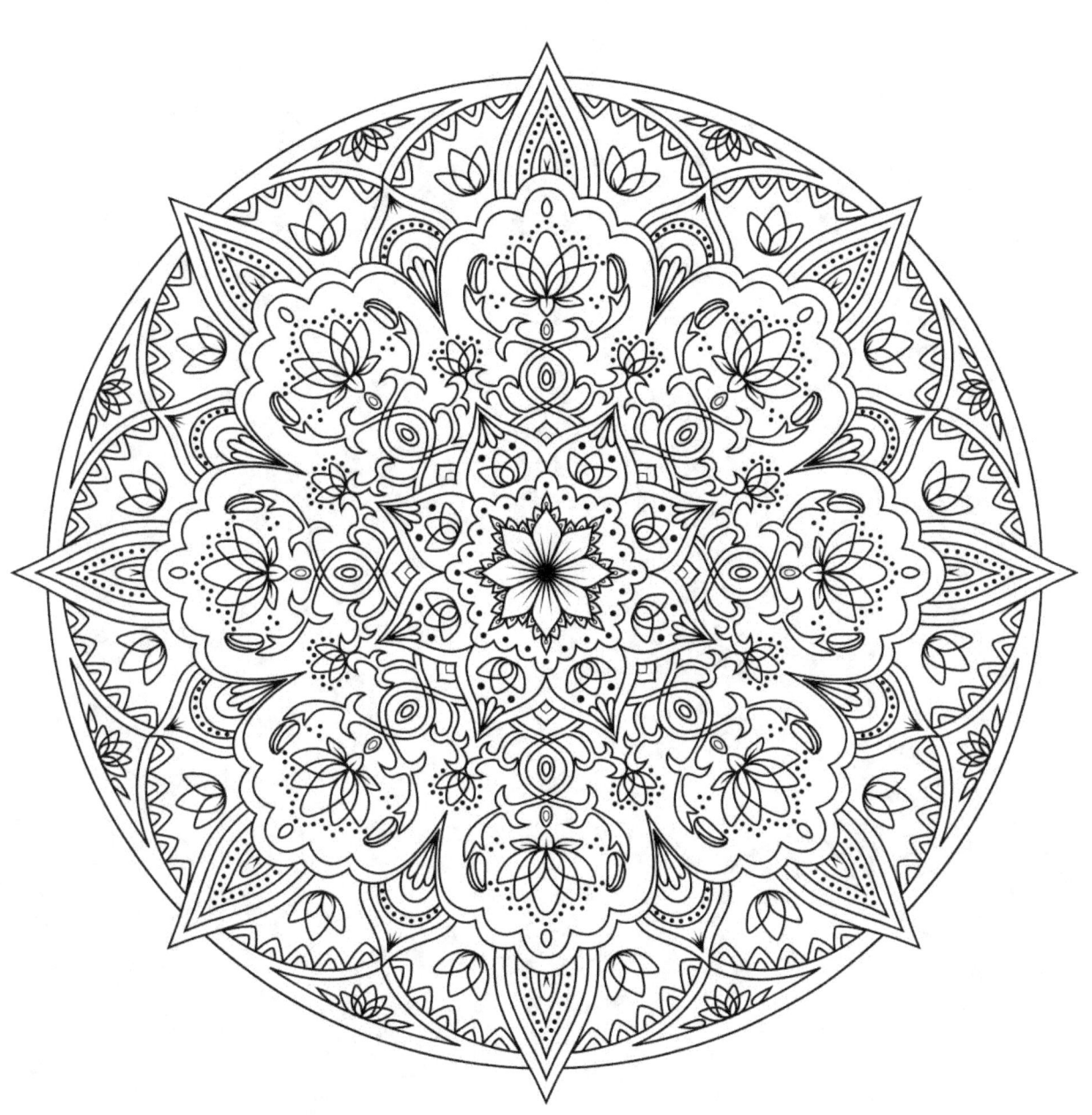

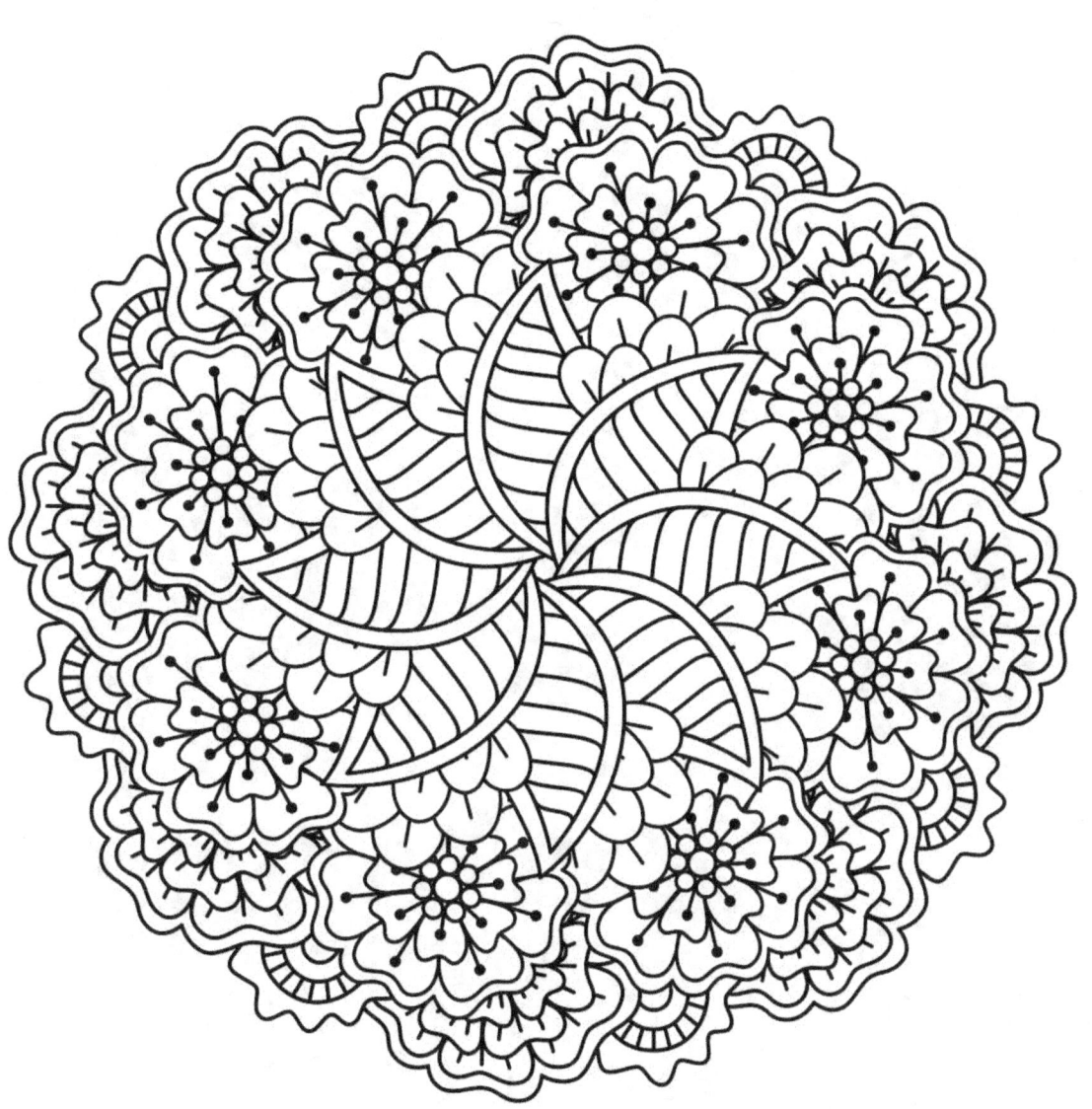

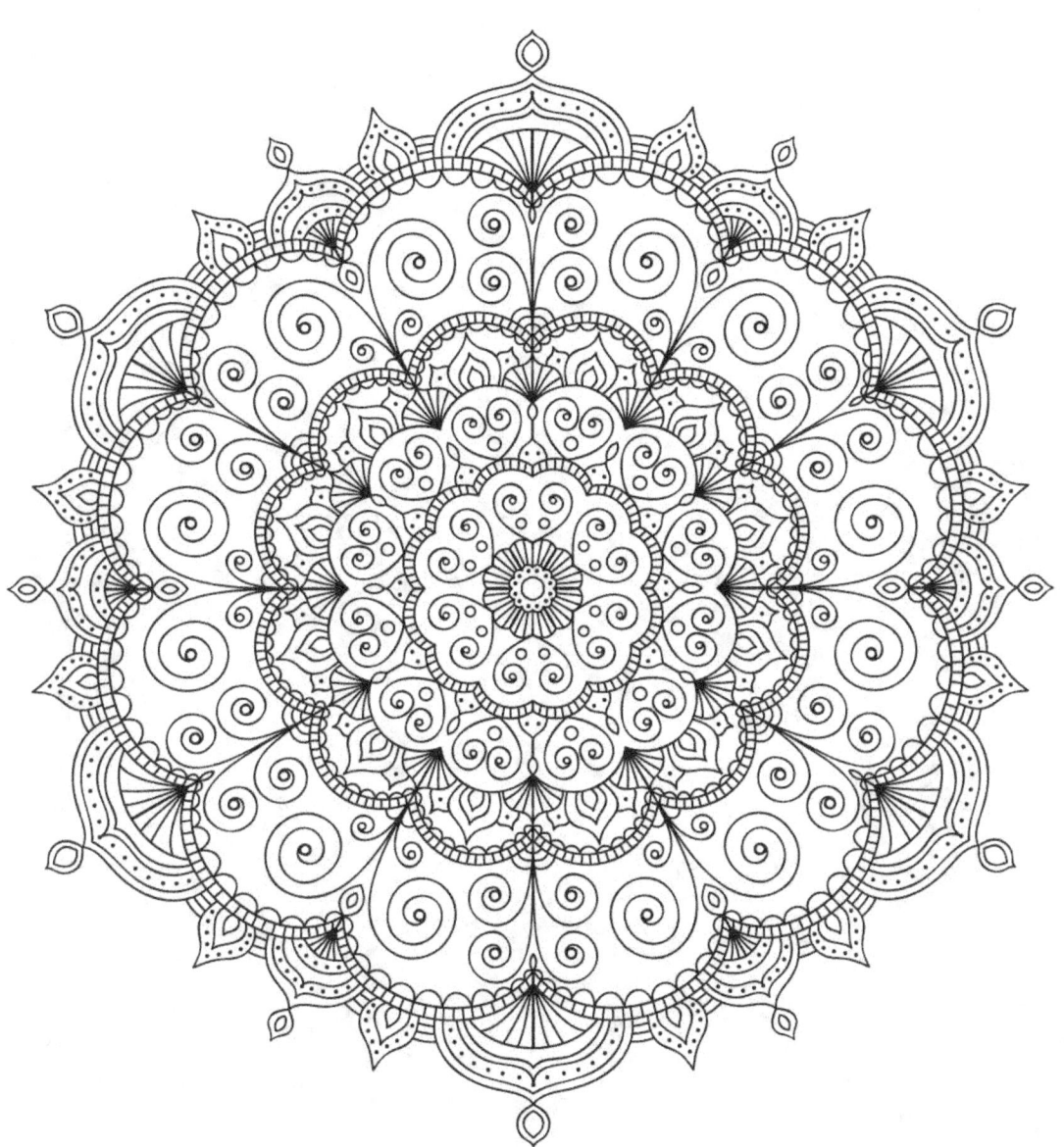

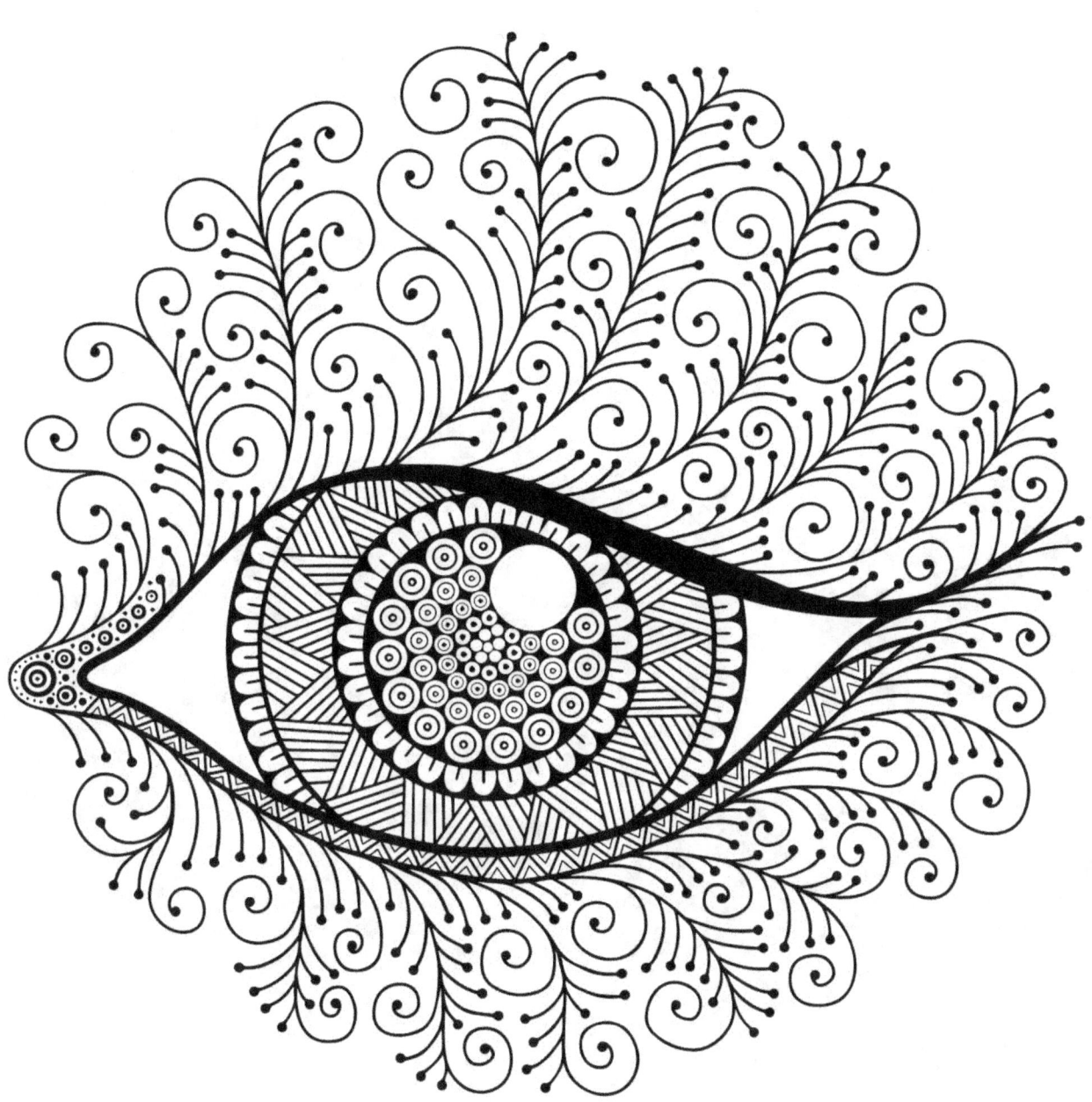

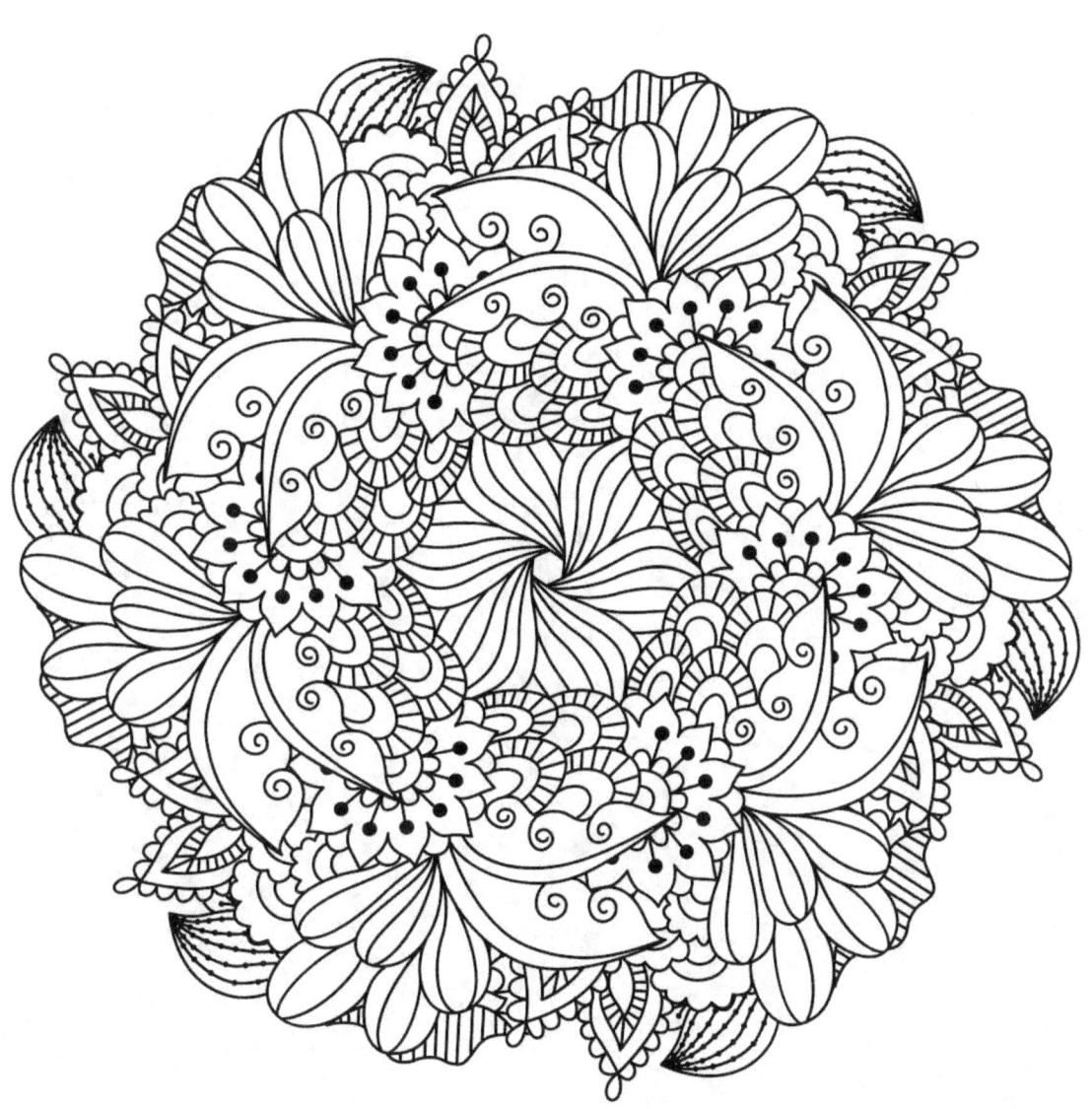

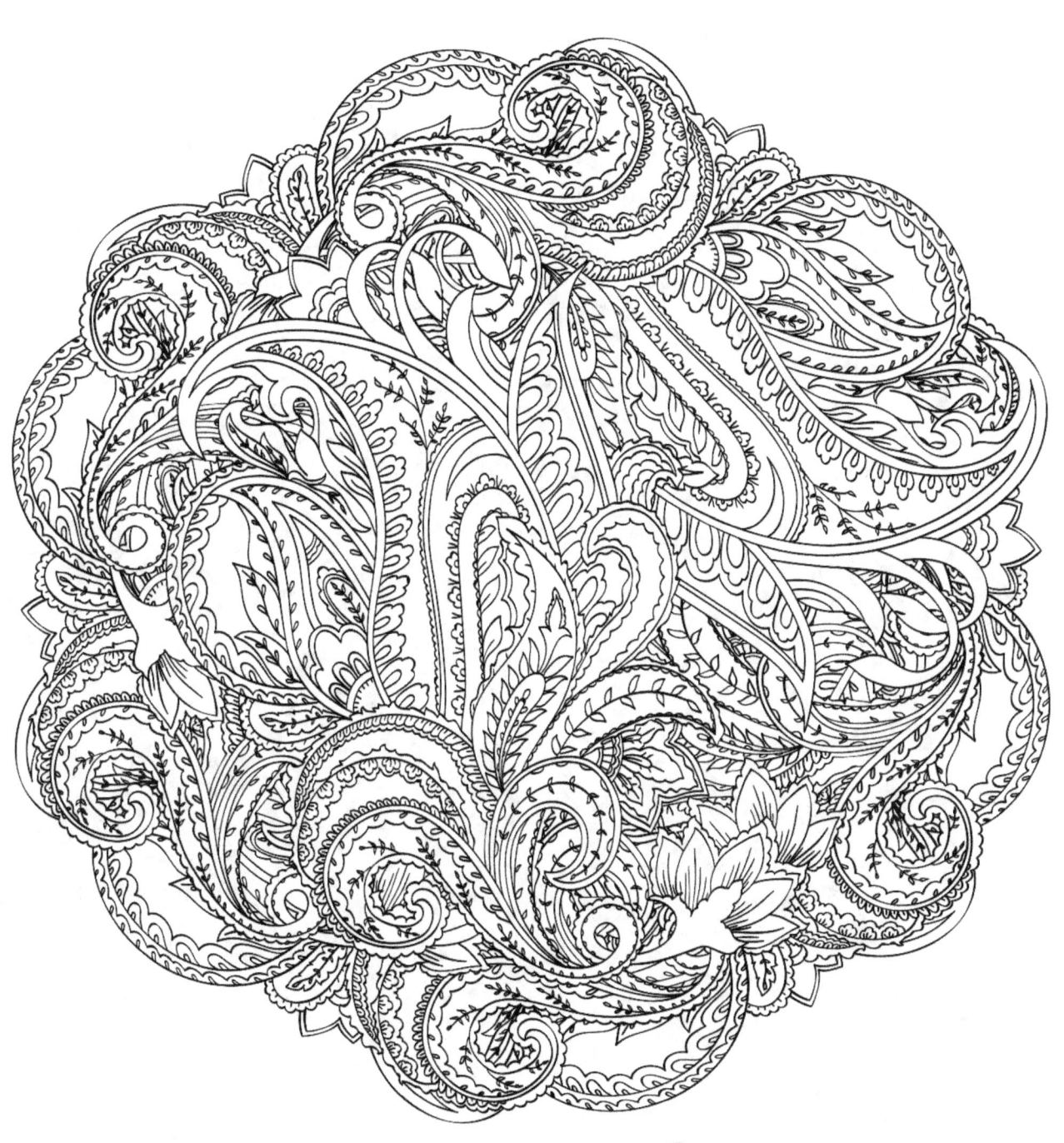

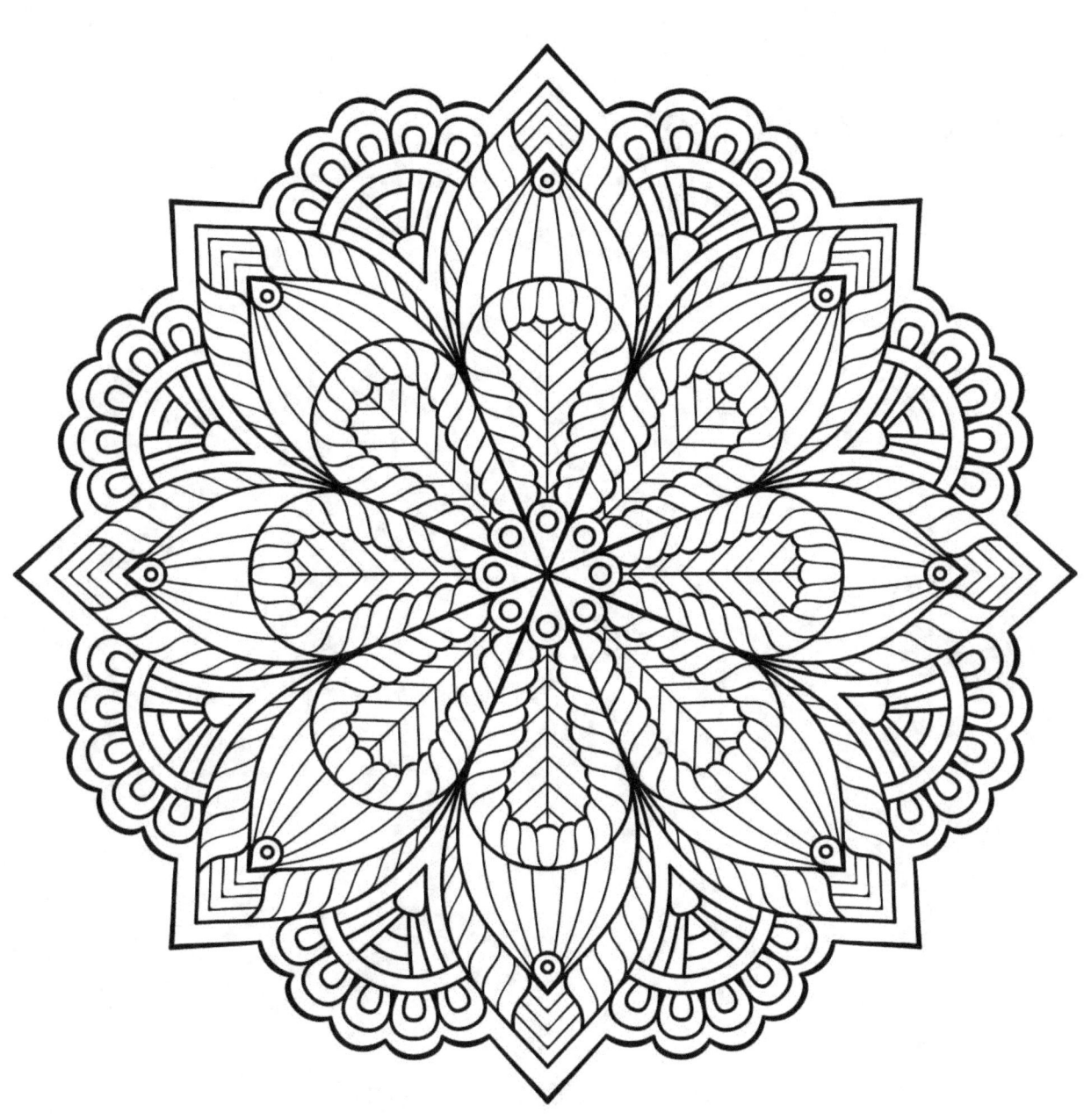

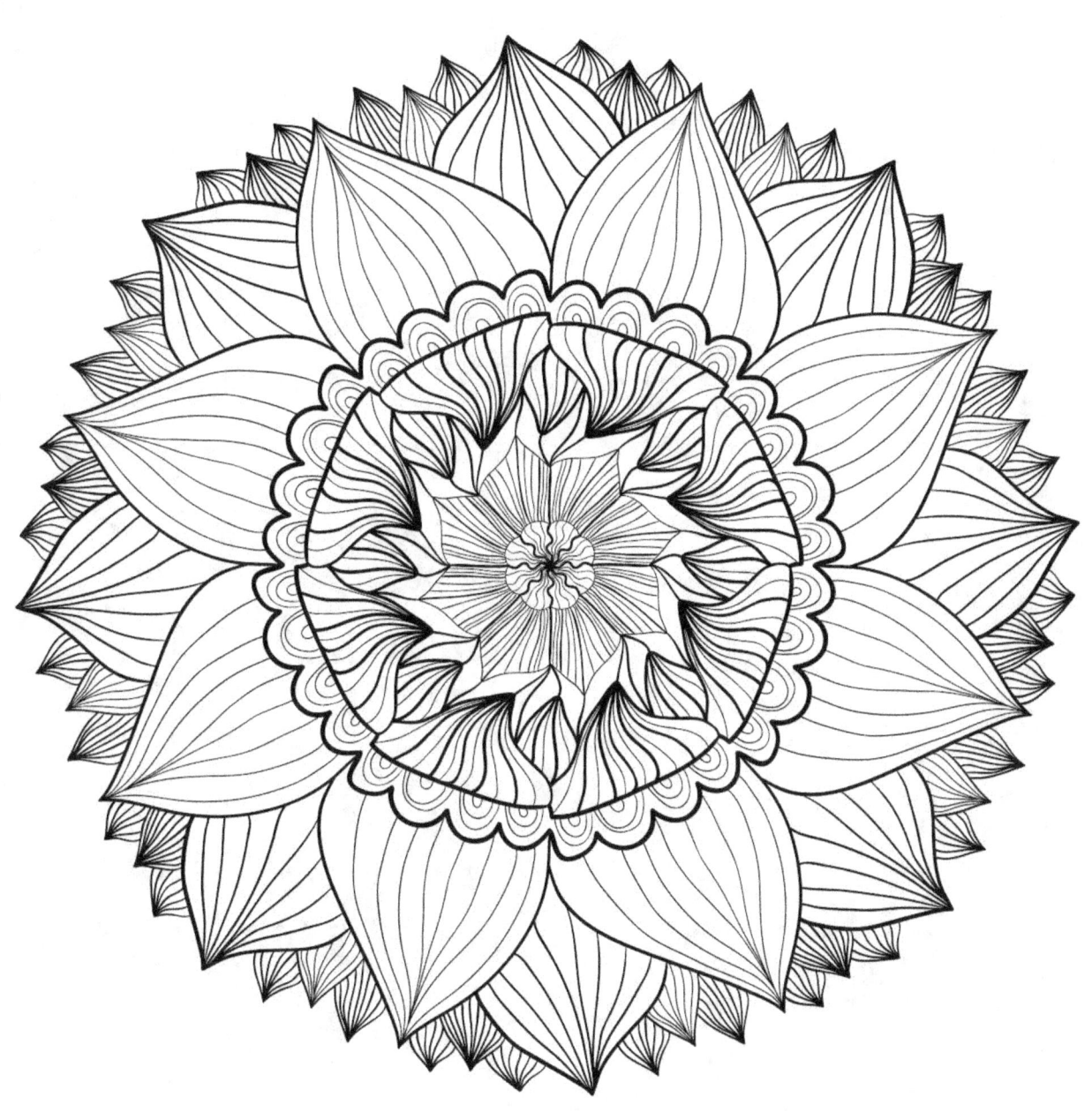

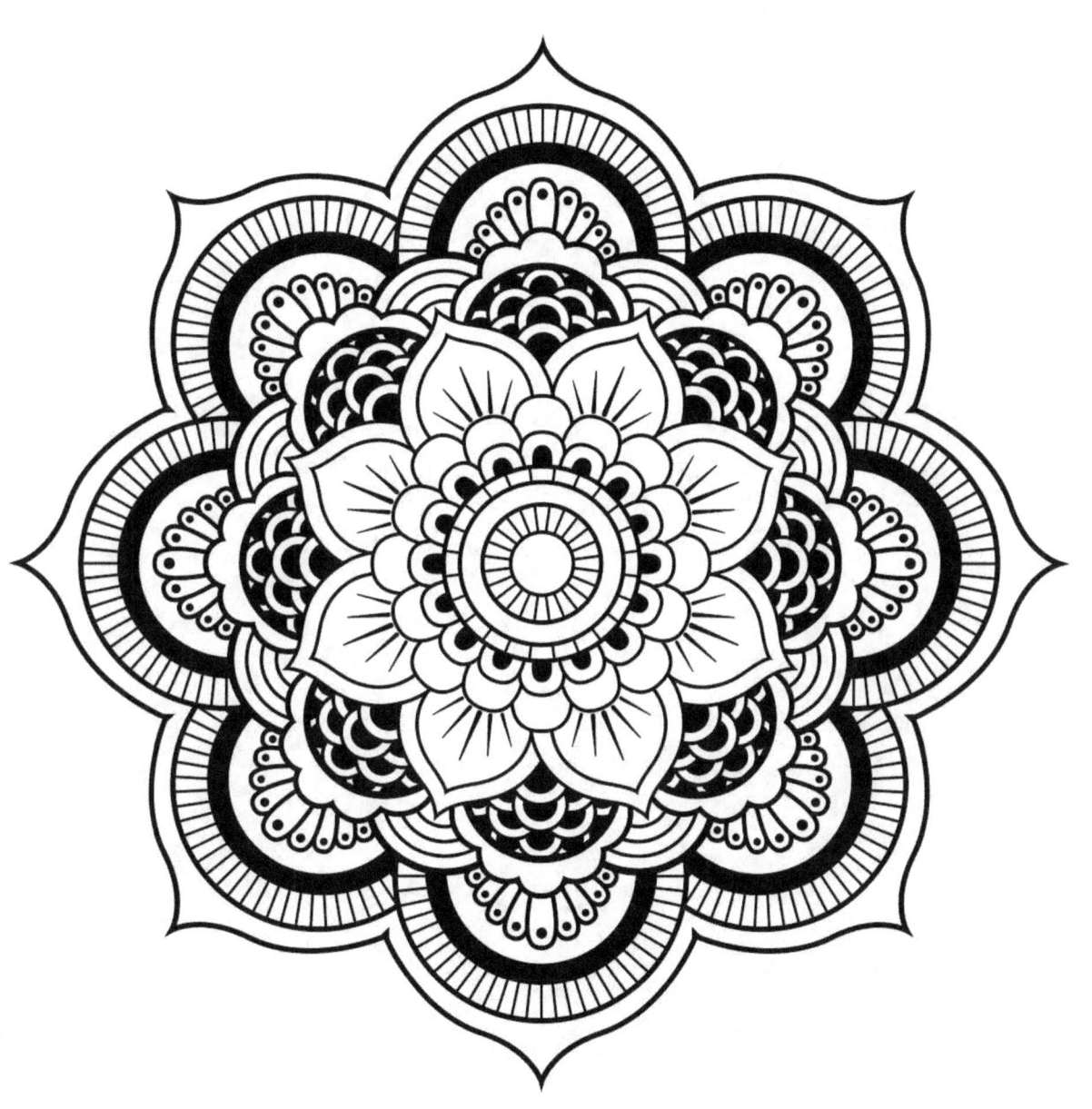

Download a PDF and print your favorite images

http://docdro.id/R781JKM

Thank you so much again for buying this book! I hope you enjoyed coloring my book. Now I'd like ask for a *small* favor. Could you please take a minute or two and leave a review for this book Amazon. It'd be greatly appreciated! And I truly value your opinion and thoughts and I will incorporate them into my next book, which is already underway.

www.ingramcontent.com/pod-product-compliance
Lightning Source LLC
Chambersburg PA
CBHW081117180526
45170CB00008B/2880